UKRAINIAN EASTER EGG DESIGN BOOK 2

by
Luba Perchyshyn
Johanna Luciow
Natalie Perchyshyn

Ukrainian Gift Shop, Inc. • 2422 Central Avenue N.E.
Minneapolis, Minnesota 55418

Introduction

This is the second book in a series of Ukrainian Easter Egg Design Books. It is intended for people who wish to learn how to decorate pysanky (Ukrainian Easter eggs), and for people who want to improve their current skills. Complete step by step instructions are given for 24 traditional and original designs. Materials needed, removing wax, varnishing, emptying eggs, and hanging eggs are explained. Pysanky are filled with symbolic art. The meanings of the main symbols and colors are briefly explained.

It is our hope, that after completing the eggs in this book, you will find an art to be enjoyed for years to come.

ISBN Number: 0-9602502-4-7

Other books published by the Ukrainian Gift Shop, Inc.:

Eggs Beautiful, 1975, 1976, 1980, 1984, 1987, 1991
Ukrainian Easter Eggs and How We Make Them, 1979, 1981, 1987, 1990, 1994
This Was the Day, 1981
Ukrainian Embroidery, 1984, 1993
Ukrainian Design Book - Book 1, 1984, 1986, 1990, 1994
Ukrainian Easter Egg Design Book 2, 1986, 1990, 1995
Ukrainian Easter Egg Design Book 3, 1995

Table of Contents

Chapter Six
Finishing the eggs . 87

Color Plates

Chapter One
Working Area

Protect the work table with a few layers of newspaper. Place a few sheets of paper towels in a small stack in front of you to cushion the area where you will be working.

Set up a good source of light to see well and to avoid shadows on the egg.

If you work for long periods of time, you will be more comfortable sitting up straight with both feet on the floor. Rest your arms on the table.

Chapter two
Essential Materials

Eggs

When shopping for eggs suitable for pysanky, the best source is to get unwashed eggs directly from an egg farm. If they are just laid, let them stand 4 or 5 days before decorating. Some eggs purchased at stores do not take the dyes well because they were washed with a strong solution that is not compatible with the dye. If farm eggs are not available, shop at a few stores until you find a good source. Chicken eggs are most commonly used. Duck, goose, and ostrich eggs are also popular.

Use raw white eggs that don't have cracks or weak spots. Jumbo and extra large eggs tend to have weaker shells; therefore, use medium or large eggs for decorating. Old eggs float, making dying difficult.

If washing is necessary, rinse carefully (without rubbing) with a solution of 2 tablespoons white vinegar and one quart of tepid water. Blot the egg dry or let them air-dry on a towel. Do not use detergent or soap.

Work on eggs that are at room temperature.

It is Ukrainian tradition to allow pysanky to remain whole. The inner egg was not disturbed because it was considered alive. Blown eggs were used for good luck and protection from the evil eye.

Eggs may be blown either before or after decorating. If you decide to blow your eggs first, the holes in the shell must be sealed before dying. More information on blowing and working on empty eggs can be found in Chapter Six.

Kistka (writing tool)

The kistka comes a in variety of styles and sizes. Some are handmade and some are made by machine. Basically, a kistka is a funnel attached to a stick. Wax is scooped into the funnel, heated, and then drawn across the egg. There are two main types of kistky (plural of kistka), the ones heated with a candle and the electric kistky.

I. Candle heated kistky

1. Traditional kistka - handmade, comes in fine, medium, and heavy sizes. This tool has been used for many years. It has a brass funnel wound with copper wire and a wooden handle.

2. Brass kistka - precision tooled, available in fine, medium, and heavy sizes. It has a brass tip and a delrin (plastic) handle.

II. Electric kistky

1. Stationary tip kistky - comes in sizes extra-fine, fine, medium, heavy, and extra-heavy. The tips are not removable except for replacement.

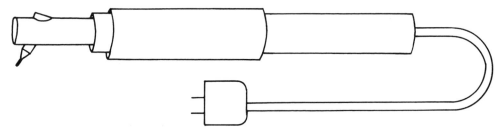

2. Interchangeable kistka - comes in fine, medium, and heavy. An extra-fine and extra-heavy tip can be purchased separately.

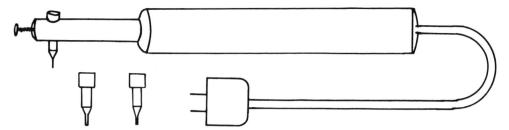

You will need fine, medium, and heavy kistky to make the eggs in this book.
For more intricate eggs, you may also use an extra-fine kistka.

2

Dyes

We have found the non-edible aniline dyes to be the very best. They come in the following colors: yellow, gold, orange, scarlet, red, dark red, brick, brown, pink, purple, light blue, light green, royal blue, dark green, turquoise, and black. Once they are mixed with boiling water, the dyes can be kept about a year in a covered jar. Note: the dyes will last longer if they are made with distilled water.

Make dyes in advance and cool to room temperature. To prevent cracking of the jars, warm them with a little hot water before putting in the dye and boiling water. A further precaution is to place the jars in the sink while making the dyes. Use widemouth jars so it will be easy to dip the eggs in and take them out of the dyes. Follow the directions on each color packet. A good suggestion is to save each envelope and tape it to the jar. This will help you identify the color and know which dye requires vinegar. Vinegar evaporates with time. One or two tablespoons of white vinegar may be added when the dye gets weak. Keep the dyes covered when not in use to avoid evaporation. We have developed some helpful techniques in regards to specific dying processes and control of color itensity on the eggs.

Small accents of blue or green: It is not necessary to dip the egg for covering small areas with blue or green color. If you wish a light blue accent in your design, after the white egg has been completed with the wax process, dab some light blue dye with a cotton swab in the areas desired. Pat dry and cover with wax. Then, dip into yellow as the next step. For green accents, dab the areas with light blue or light green dye over the yellow egg. Pat dry and cover with wax.

You do not have to be too precise about applying the dye with the swab. Any area not covered with wax will dissolve in the orange dye.

Orange wash: Have an extra orange dye and use it only to rinse out darker colors. Orange can rinse out greens, blues, reds, and brick. After using the orange rinse, you can go to a different color scheme.

Diluted blue: For a beautiful light blue, follow this recipe; to one cup of water, add 1 tablespoon of vinegar and 2 tablespoons of prepared light blue dye. Use this dye to get a lighter, brighter blue.

Bleaching: If a white background is desired, a different sequence of color is used on the egg. For example, the egg is first dipped into a dye (yellow, orange, red or brick) and then the basic design is drawn in that color. Afterwards, the egg goes into lighter or darker colors, depending on the desired effect.

For a white background, gently wash the egg in a solution of 2 tablespoons bleach in one cup of cool water. After the uncovered shell has become completely white, rinse the bleached egg under cool running water. When the egg no longer feels slippery, wipe with a tissue. Allow the egg to air-dry at least 1/2 hour before removing the wax from the shell.

Beeswax

Wax seals the color of the surface it covers. Pure beeswax is the only type of wax used with this egg dying process. Regular light beeswax is used with kistky which are heated in the candle flame. This wax will gradually turn black from the carbon in the flame. Darkened beeswax is available for the electric kistky as it is needed to see the design and areas being filled in. One of the last steps in decorating pysanky is to remove the wax which allows the colors beneath to reappear.

Candle

A candle on a secure holder is needed to heat the traditional or brass kistky. Short candles offer an easier reach. Candle wax is not used for decorating the egg. The candle is also one of the methods used to melt the wax from the egg at the end of the process.

Pencil

When dividing the egg at the beginning, use a #2 or #3 pencil. The pencil lines will not show later if they are drawn lightly. They help to create a balanced design. The most experienced egg decorator uses pencil lines for their division. Do not erase pencil lines because the dye will not take to the shell in that area.

Spoons

Use stainless steel tablespoons for dipping the eggs in and out of the dyes. Have a jar with plain water in it; let the spoons sit in the water when they are not in use. This keeps the spoons clean.

Cotton swabs or small paintbrush

A cotton swab or a small paintbrush is used to add dye to small areas in the design. Cotton swabs dipped into cleaning fluid are also used to remove unwanted wax (see cleaning fluid on page 6).

Soft cloth and paper towels

Paper towels are used to pat the eggs dry when they come out of the dye. Paper towels are also used to cushion the egg on the table while working. Soft cloth or paper towels are used to wipe the melted wax from the egg in the final step.

White vinegar

White vinegar is added to most of the dyes to keep them strong. Also, if the eggs need washing, use a solution of 1 teaspoon vinegar and 1 cup of water.

Varnish and hand soap

Varnish adds protection and luster. A clear fast drying glossy varnish or polyurethane wood finish is recommended. Do not use water soluble varnish; it causes the dyes to run.

Waterless hand cleaner takes the varnish off your hands easily and gently. Both of these products may be purchased at your local hardware store.

Drying rack

The drying rack is a small board with nails that holds up to 15 eggs. It is used for melting wax off the eggs in the oven, as well as, used for drying after the varnish is applied.

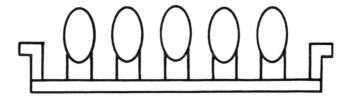

Chapter Three
Optional Materials

The following supplies are optional, but very useful in decorating pysanky.

Egg lathe

The egg lathe is a device used to draw horizontal lines around the egg. The lathe can be adjusted for goose, chicken, and most pullet eggs.

There are some eggs in this book which were made using the lathe.

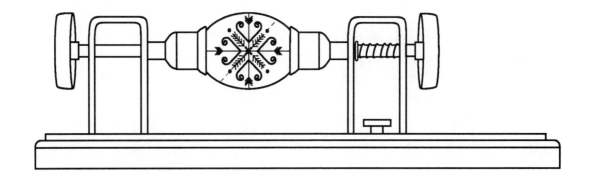

Cleaning fluid

Cleaning fluid is used to remove unwanted wax from the shell. First, scrape the wax off with your finger nail. Then, with a cotton swab which has been dipped into cleaning fluid, rub gently and remove the spot with a roll and lift motion. Keep the cotton swab damp and not soaked with cleaning fluid so it doesn't run into the rest of the design.

After melting the wax, you may remove carbon and traces of beeswax from the shell with a soft cloth or paper towel which has been dampened with cleaning fluid. Do not rub. Wipe gently.

Egg blower

The egg blower is a specially designed rubber bulb used for emptying the contents of the egg. The egg can either be blown with one or two holes.

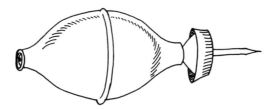

Findings

A finding is a gold colored metal hanger which is glued to the top of a blown egg. After applying a drop of glue to the top of the egg, place the finding on it and allow to dry. Then, string a cord or fine ribbon through the loop in the finding for hanging.

Chapter Four
Basic Pencil Divisions

Before applying wax lines, draw the basic divisions on the egg with pencil lines. These will be guidelines and will not show later if they are drawn lightly. It is better to make long smooth lines. Do not erase.

The following divisions are used in more designs than any other. Practice until you are comfortable with them.

Basic Division A

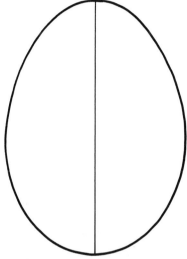

1. With pencil, lightly draw a line around the egg vertically, dividing the egg in half.

2. Now draw another line dividing the egg into fourths vertically.

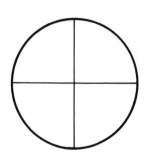

3. Top view of egg when step 2 is completed.

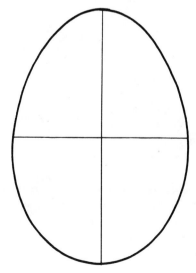

4. Divide the egg horizontally.

Basic Division B

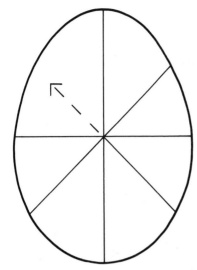

Start with basic division A, and then at the center point, draw lines dividing the egg into 16 equal parts. It should look the same on both sides.

Basic Division C

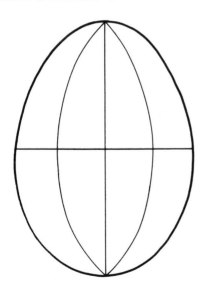

Start with basic division A, and then at the TOP of the egg, divide the egg into 16 sections with 2 additional vertical lines. The egg will look the same on both sides.

Top view of egg.

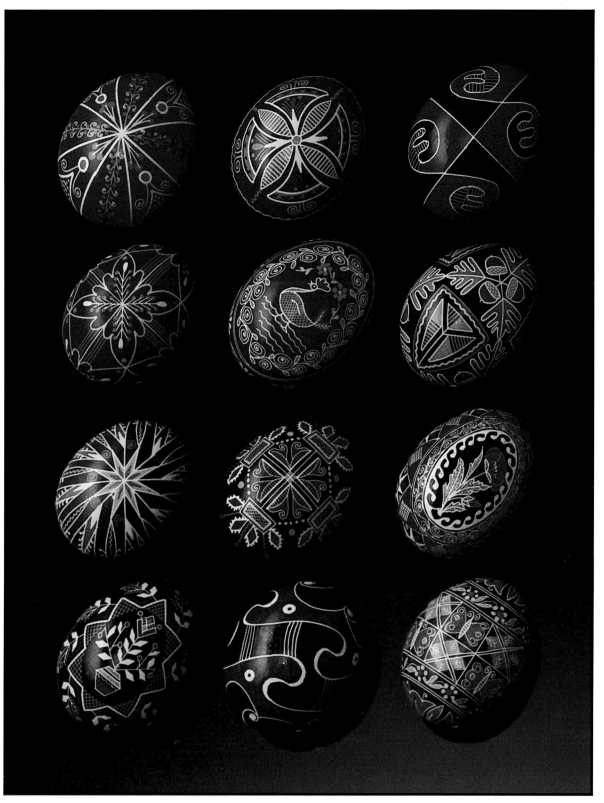

Row 1: Egg No. 1, 2, 3 Row 3: Egg No. 7, 8, 9
Row 2: Egg No. 4, 5, 6 Row 4: Egg No. 10, 11, 12

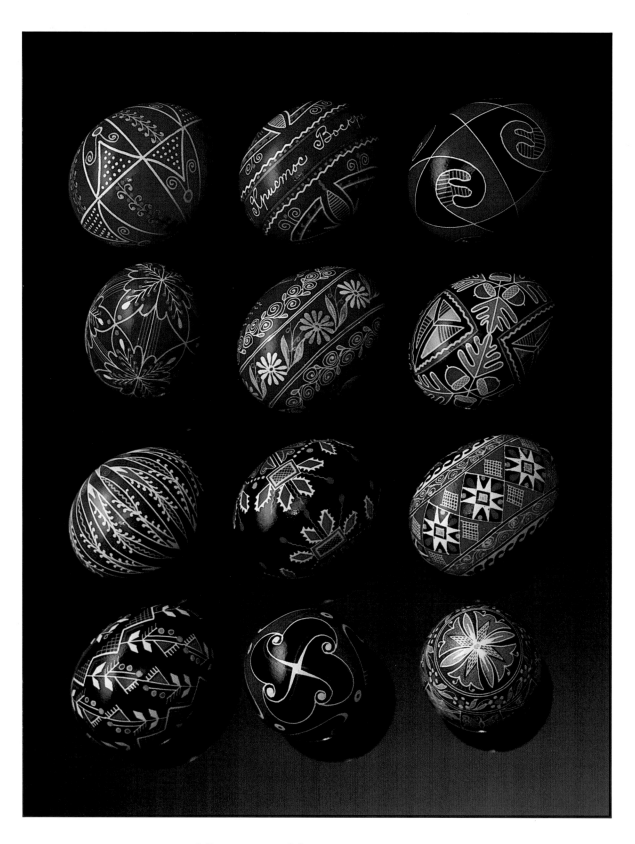

A different view of the same eggs on page 9.

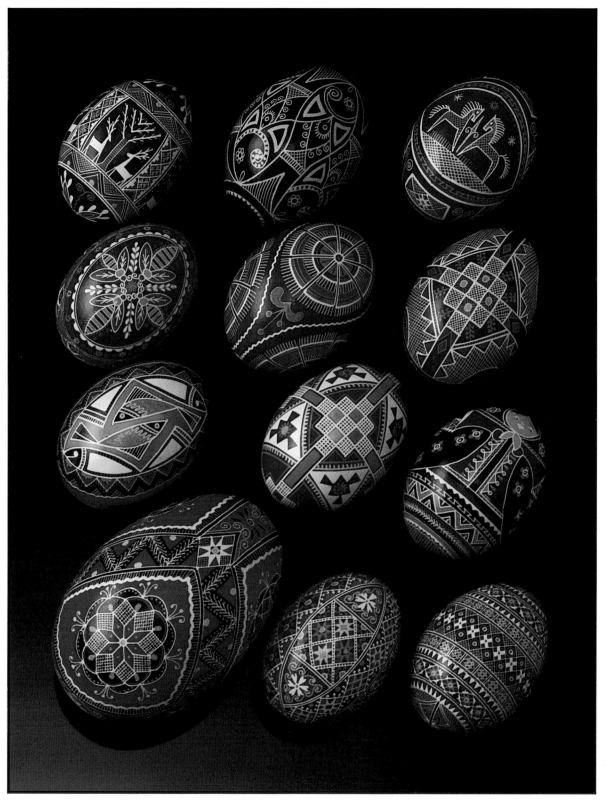

Row 1: Egg No. 13, 14, 15 Row 3: Egg No. 19, 20, 21
Row 2: Egg No. 16, 17, 18 Row 4: Egg No. 22, 23, 24

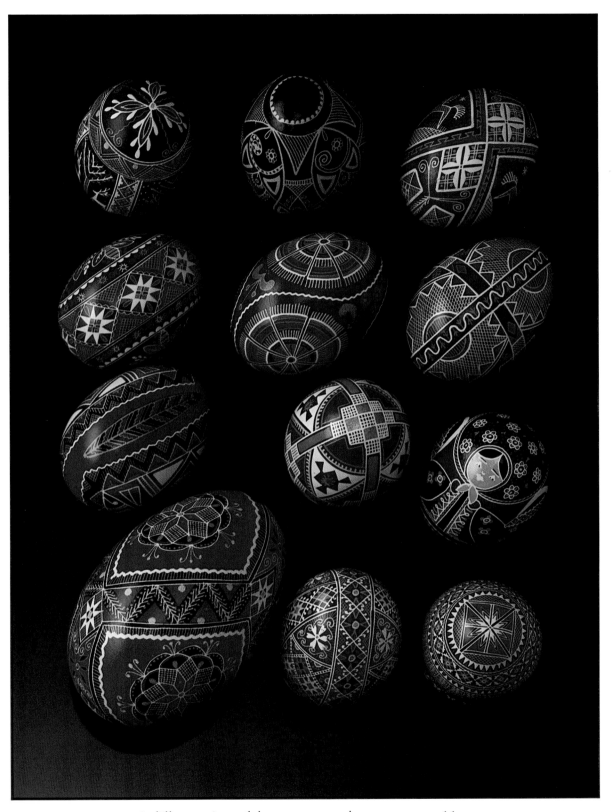

A different view of the same eggs shown on page 11.

Chapter Five
How To Make Egg
Number 1

Cross

Pencil:

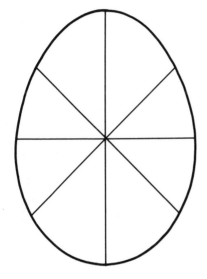

1. Divide the egg into 16ths using basic division B.

3. Draw curved lines and circle in the divided sections.

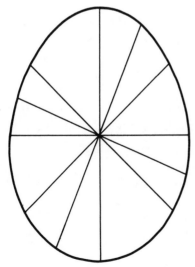

2. Divide every other section in half.

4. Divide open sections in half.

Kistka:

WHITE

1. Now you are ready to apply the beeswax to the shell with your kistka. Use a heavy or medium kistka and heat it in the candle flame (not on top). Scoop a small amount of beeswax into the funnel. Reheat for a few seconds and write with the funnel tip on the egg in the same sequence that you drew the pencil lines in step one. Add the curved lines, circles, and dots. Wherever you have applied beeswax to the white shell is where you will have white on the completed design. Beeswax seals the color of the surface it covers.

BLUE

2. Dip a cotton swab into the blue dye. Roll the swab against the inside of your dye jar so the swab is not dripping wet, or you may dab the swab on a tissue to remove the excess dye. Apply the blue dye to every other section. Start by placing the swab at the center of the egg and pull it out to the edge. Pat dry with a tissue. Use a medium kistka to write the lines and small curls.

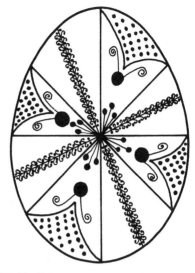

YELLOW

3. Use a spoon to lower the egg into a jar of yellow dye. Leave the egg in the dye 5 to 15 minutes. Stir very gently at least one time. Remove the egg from the dye and pat dry with a paper towel. Allow to air-dry a few minutes before applying wax with your kistka. Use a medium kistka to write in lines and large rams horns in each section with the circle.

ORANGE

4. Dip the egg into the orange dye (5 to 15 minutes), remove, pat dry, and air-dry. Use the heavy kistka to apply dots and fill in circles.

PINK

5. Use pink or red for your final dye bath. Stir gently a few times. Remove the egg from the dye and pat dry. Allow the egg to dry about 15 minutes before removing the beeswax. See Chapter 6 for directions about removing wax from the egg.

CROSS
One of the many varieties of crosses used on pysanky. In pre-Christian times the cross was used as a symbol of life. Ukrainians adopted Christianity in 988 AD and have used the cross exclusively as a symbol of Christian faith.

APPLES
Fruits of harvest denote knowlege, health, and wisdom.

DOTS
Symbolizes that from sorrow come unexpected blessings.

PINK
Success.

Egg Number 2

Stylized Butterfly

Pencil:

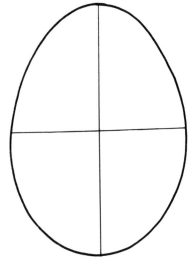

1. Divide the egg into 8ths using basic division A.

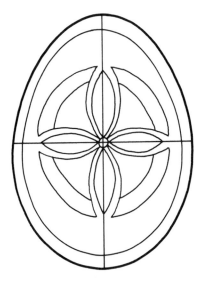

FRONT VIEW

3. Start by drawing the small circle in the center of the pattern. Next, draw the loops, and then the remaining pattern.

SIDE VIEW

2. Add parallel lines. You may pencil Xpucmoc Bockpec (Christ is Risen) if you choose.

Kistka:

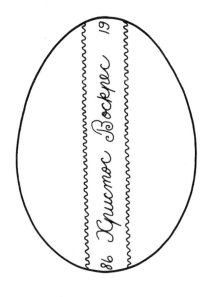

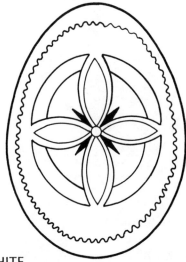

WHITE
1. Use fine kistka for the circle, loops, and words. Use medium or heavy kistka for the rest.

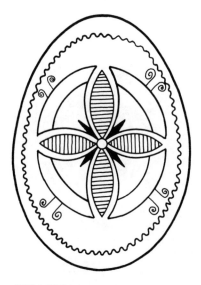

YELLOW
2. Fine kistka.

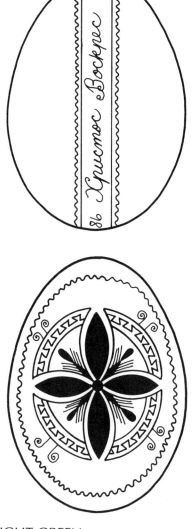

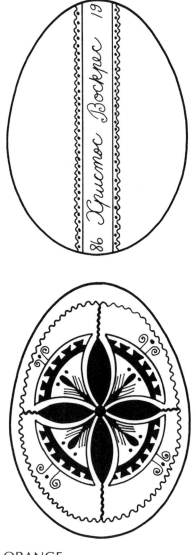

ORANGE
4. Medium kistka.

DARK RED
5. Final color.

LIGHT GREEN
3. Dip the egg into the light green dye.
 Use fine and medium kistky.

BUTTERFLY
Stylistic design (as opposed to natural) to represent the Resurrection.

RAMS' HORNS
Leadership and the kind of strength that overcomes problems.

WATER
Symbolizes wealth, no crop without rain.

LIGHT GREEN
Spring, new growth and hope.

Egg Number 3

Bear Paw

Pencil:

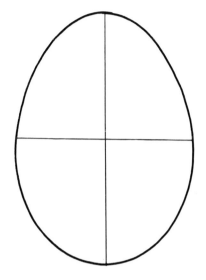

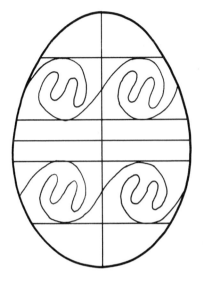

1. Divide the egg into 8ths using basic division A.

3. Draw bear paws.

Kistka:

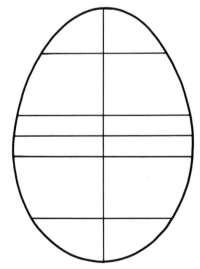

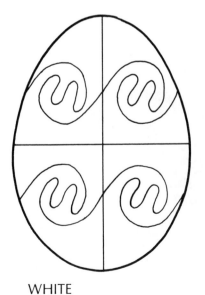

2. Add parallel lines.

WHITE
1. Medium kistka.

19

ORANGE
2. Medium kistka.

BLACK
4. Final color.

BRIGHT RED OR PINK
3. Heavy kistka.

BEAR PAW
Always depicted in red and black, red representing action, black representing fear or respect. Be careful because you can never win a battle with a bear. Another connotation of the bear is one of a protective nature that is associated with the master (male) of the home.

Egg Number 4

Four Leaf

Pencil:

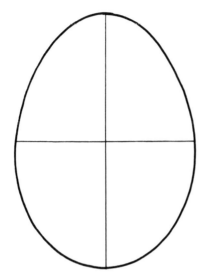

1. Divide the egg into 8ths using the basic A division.

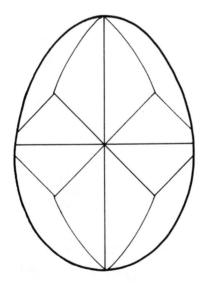

2. Draw remaining guidelines.

Kistka:

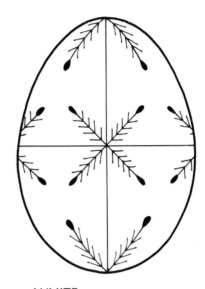

WHITE
1. Fine kistka.

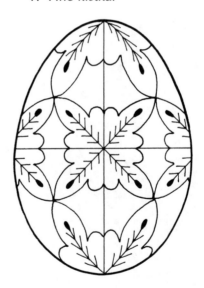

YELLOW
2. Medium kistka.

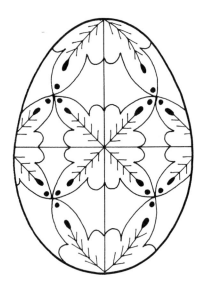

LIGHT GREEN

3. Apply either light green or light blue dye with a cotton swab to the areas needed. Use medium kistka.

DARK RED

5. Final color.

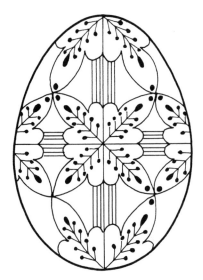

ORANGE

4. Fine and medium kistky.

FLOWER

Stylized flower is symbolic of the female principle denoting wisdom, elegance, and beauty.

DOTS

Represent stars in heaven or the tears of Mary at the crucifixion of Christ.

Egg Number 5

Bird

Pencil:

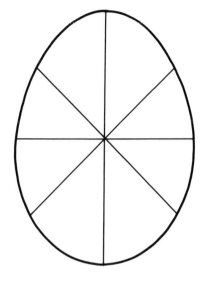

1. Divide the egg into 16ths using basic division B.

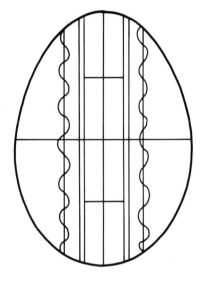

3. Add remaining lines as shown.

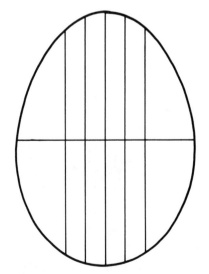

SIDE VIEW
2. Add additional guidelines.

FRONT VIEW
4. Draw the bird.

Kistka:

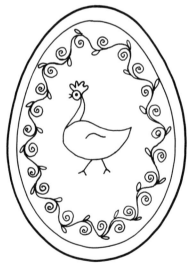

WHITE

1. Use fine kistka for parallel border lines, scroll and bird. Use medium kistka for flowers placed on the pencil guidelines.

BLUE

2. Apply a blue dye with a cotton swab in a circle on the basic dividing lines in the border. Use medium kistka.

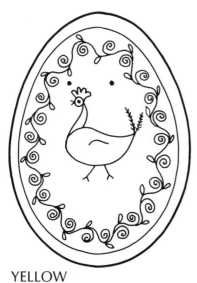

YELLOW
3. Fine kistka

GREEN
4. Apply green dye with a cotton swab to the leaves on the border and to the front of the egg as shown. The dye that is not covered with wax will wash away in the orange dye bath. Use medium kistka.

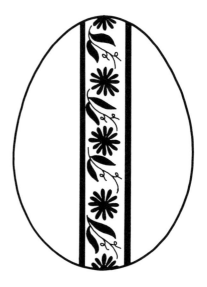

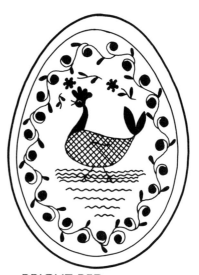

ORANGE
5. Use medium kistka for the loops on the scroll and dots. Use fine kistka for the rest.

BRIGHT RED
6. Fine and medium kistky.

DARK RED
7. Final color.

BIRDS
Most birds signify the coming of spring. Roosters, a masculine symbol, denote a rich married life and many children. Hens denote fertility, the bearer of the talismanic egg.

FLOWER
Wisdom, beauty, and humility.

MEANDER
Immortality.
DARK RED
A harvest color denoting the gathering of fruit in the fall.

Egg Number 6

Acorn

Pencil:

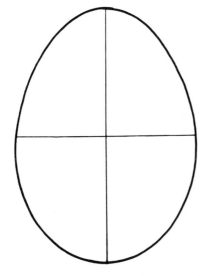

1. Divide the egg into 8ths using basic division A.

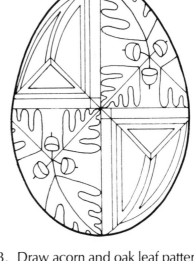

3. Draw acorn and oak leaf pattern. Draw geometric triangle pattern.

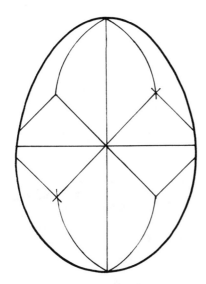

2. Draw additional guidelines.

4. A better view of each triangle.

Kistka:

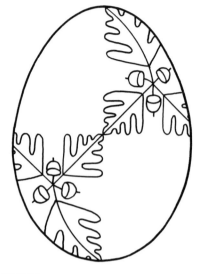

WHITE
1. Medium kistka

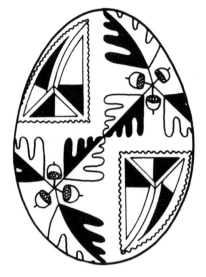

LIGHT GREEN
3. Dip the egg into light green dye. Use heavy kistka.

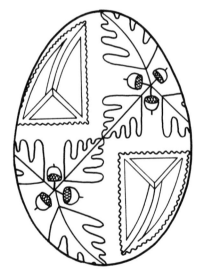

YELLOW
2. Fine, medium and heavy kistky.

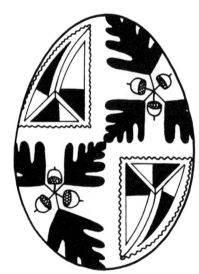

ORANGE WASH
4. To achieve another shade of green, dip egg into orange wash for a few seconds, until the desired shade appears. Use medium or heavy kistka.

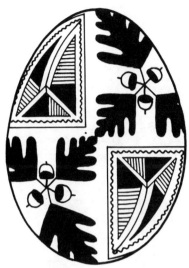

ORANGE
5. Heavy and medium kistky.

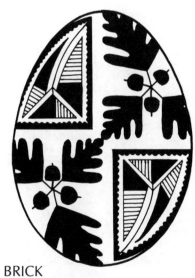

BRICK
6. Heavy kistka.

BLACK
7. Final color.

ACORN
Preparing for the future.

OAK LEAVES
Most frequently represent the strength and persistence of the mighty oak tree. Another meaning less frequently used represents the cycle of life and death, the leaf dying in fall and being replaced in spring.

TRIANGLES
Represent the Holy Trinity.

Egg Number 7

Blue Star

Pencil:

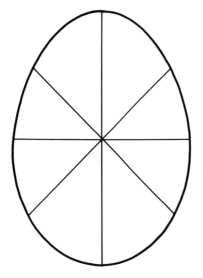

1. Divide the egg into l6ths using basic division B.

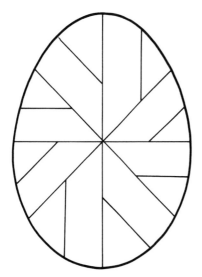

2. Draw lines parallel to each division line.

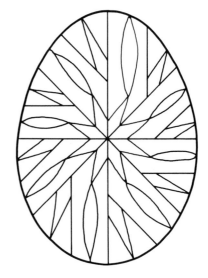

3. Draw star, loops, and points.

Kistka:

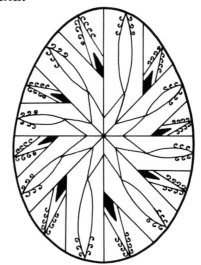

WHITE

1. Please note that the egg is only divided in half vertically in wax, not quartered. A point will meet a loop from the other side of the egg. Use fine kistka.

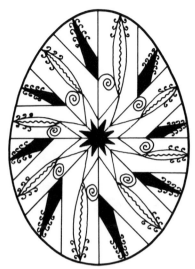

LIGHT BLUE

2. Dip egg into light blue dye. Use fine and medium kistky.

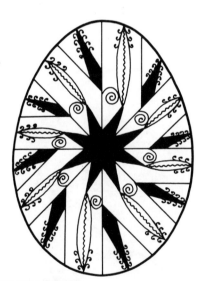

WATER RINSE

3. Put the light blue egg into a jar or glass of water to allow some of the blue dye to rinse off. Watch for the desired shade. Use a clean tissue to pat dry. Fill in the star with medium kistka.

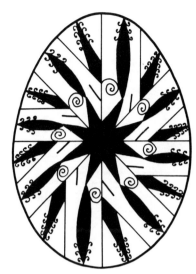

ROYAL BLUE

4. Medium kistka.

WATER RINSE

5. Put the royal blue egg into a jar or glass of water to allow some of the royal blue dye to rinse off. Watch for desired color. This will be your final color.

STAR
Eternal life and good fortune.

PODS
A plant symbol for fertility and hope for a fruitful harvest.

SPIRALS
Divinity or immortality.

LIGHT BLUE
Signifies the sky with its life-giving air and good health.

Egg Number 8

Cross

Pencil: **Kistka:**

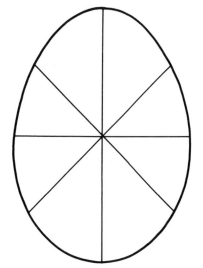

1. Divide the egg into 16ths using basic division B.

WHITE
1. Fine kistka.

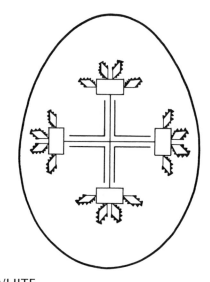

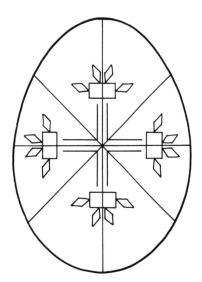

2. Draw guidelines.

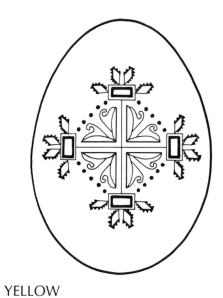

YELLOW
2. Fine and heavy kistky.

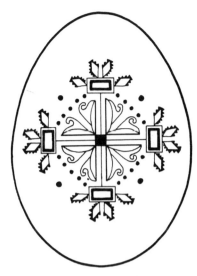

LIGHT GREEN

3. Apply either light green or light blue dye with a cotton swab to the areas needed. Use medium kistka.

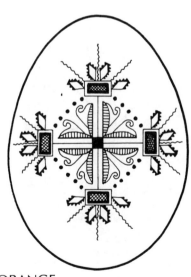

ORANGE

4. Fine kistka.

BRIGHT RED

5. Medium or heavy kistka.

BLACK

6. Final color.

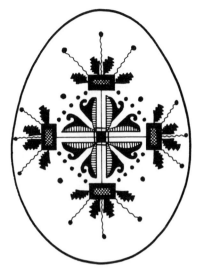

CROSS
Crucifixion of Christ.

BUTTERFLIES
Resurrection of Christ.

DOTS
Drops or dots symbolize the fallen tears of Mary as she wept for Jesus when he was on the cross.

Egg Number 9

Poppy

Pencil:

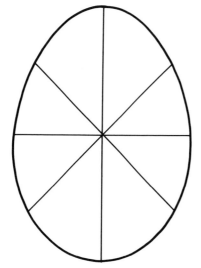

FRONT
1. Divide the egg into l6ths using basic division B.

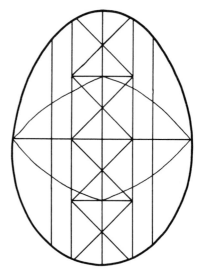

SIDE VIEW
3. Add crisscross lines to form diamonds.

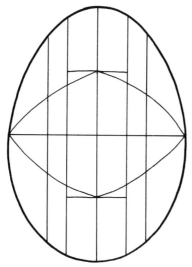

SIDE VIEW
2. Add parallel lines and divide border into eight equal parts.

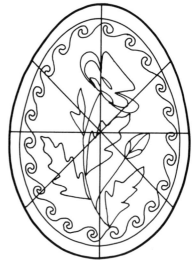

FRONT VIEW
4. Draw meander and poppy design.

Kistka:

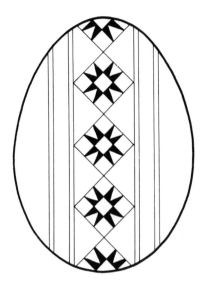

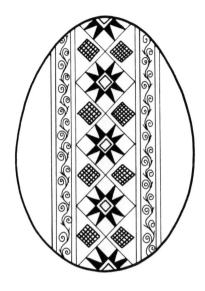

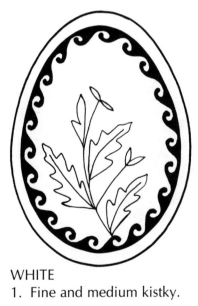

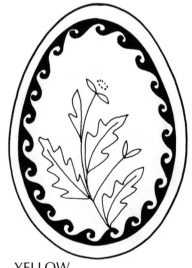

WHITE
1. Fine and medium kistky.

YELLOW
2. Fine kistka.

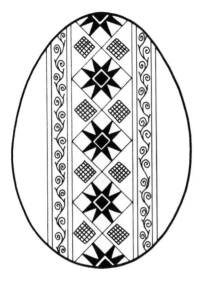

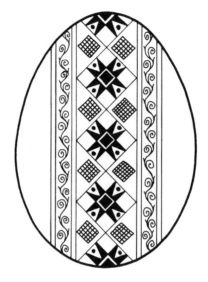

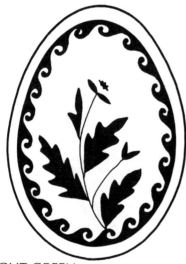

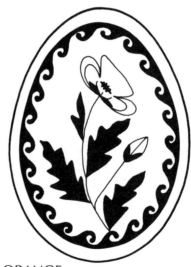

LIGHT GREEN
3. Apply either light green or light blue with a cotton swab to the areas needed. Use medium or heavy kistka.

ORANGE
4. Fine and medium kistky.

BLACK
6. Final color.

FLOWER
The poppy is a Ukrainian favorite.

MEANDER
Eternity and everlasting life.

PETAL
This shape is commonly used on pysanky and represents a flower petal which has the same meaning as the entire flower — beauty, elegance, and humility.

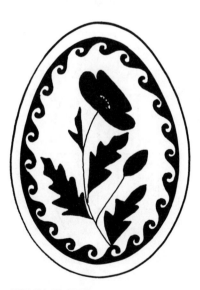

BRIGHT RED
5. Heavy kistka.

Egg Number 10

Flower Pot

Pencil:

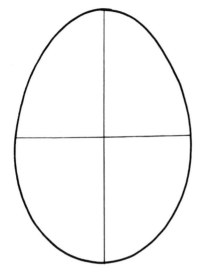

1. Divide the egg into 8ths using basic division A.

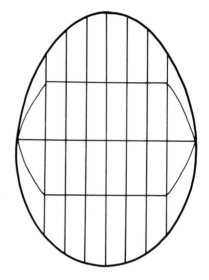

3. Return to the front of the egg and divide each quarter in half as if you are using division B, only stop at the first vertical guideline.

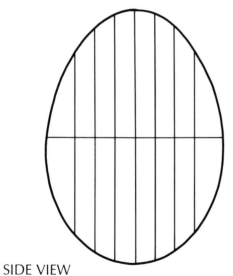

SIDE VIEW
2. Draw additional vertical lines.

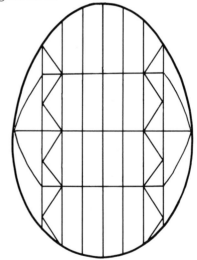

4. Draw zigzag lines as shown.

Kistka:

5. Complete additional guidelines.

WHITE
1. Use heavy kistka for zigzag lines and fine for the rest.

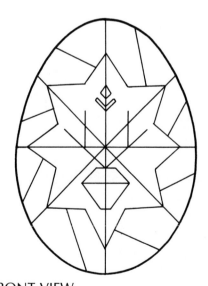

FRONT VIEW
6. Draw the flower pot.

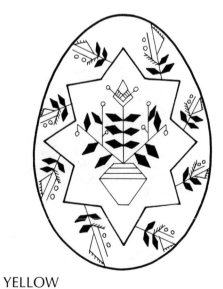

YELLOW
2. Fine kistka.

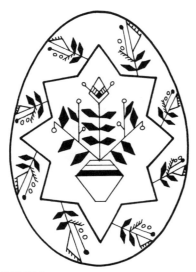

LIGHT GREEN
3. Apply either light green or light blue dye with a cotton swab to the areas needed. Use medium kistka.

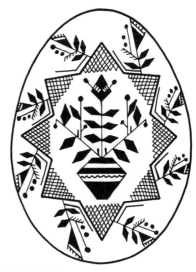

BRIGHT RED
5. Medium kistka.

BLACK
6. Final color.

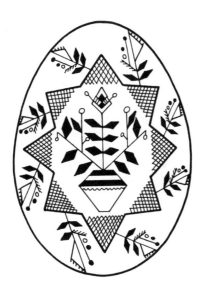

ORANGE
4. Fine kistka.

FLOWER POT
Love, charity, and goodwill.

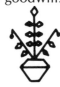

SIEVE
Symbolizes the dividing of good from evil.

DIAMOND
Geometric symbol used in profusion on pysanky, indicates knowledge.

BLACK
Eternity, darkest time before dawn.

Egg Number 11

Trypillian

Pencil:

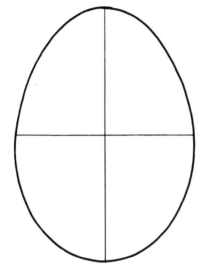

1. Divide the egg into 8ths using basic division A.

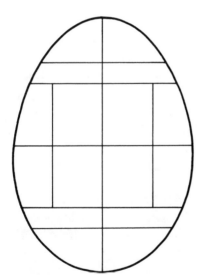

2. Add parallel lines and divide each section in half as shown.

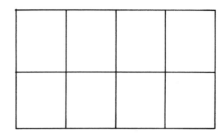

3. We are using the eight section flat diagram because it is easier to understand the pattern. The eight sections represent half the egg excluding the top and bottom.

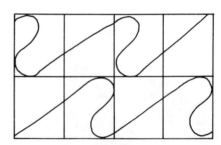

4. Place S's as shown.

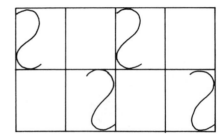

5. Connect S's.

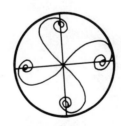

TOP AND BOTTOM
6. Draw spirals.

Kistka:

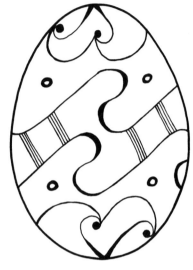

WHITE
1. Medium and fine kistky.

BLACK
3. Final color.

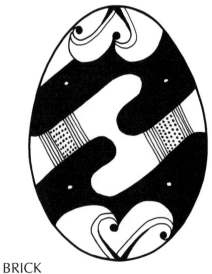

BRICK
2. Heavy and medium kistky.

TRYPILLIAN EGGS
Trypillians are an ancient tribe of people that lived and thrived in the area of Ukraine 6000 years ago. Pieces of their pottery were found near the little city of Trypillia only 40 kilometers from Kiev. The pottery designs adapt beautifully to the egg. Designs are of 3 colors - white, black, and clay red(brick). The designs are spirals and meanders which signify eternity and the cycle of life.

Egg Number 12

Naturalist Butterflies

Pencil:

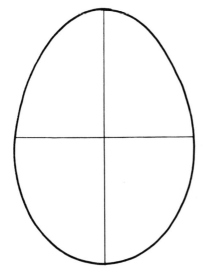

1. Divide the egg into 8ths using the basic division A.

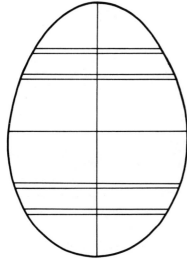

2. Add parallel lines.

3. Divide each section in half. Complete top as shown.

Kistka:

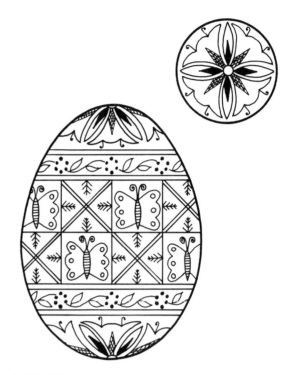

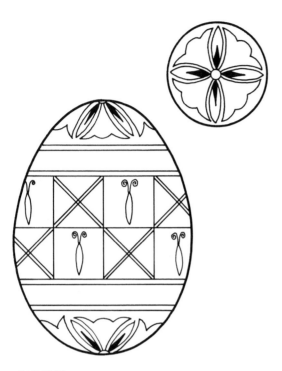

WHITE
1. Medium kistka.

YELLOW
3. Fine kistka.

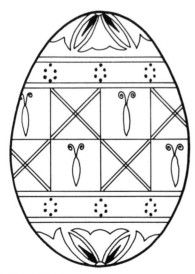

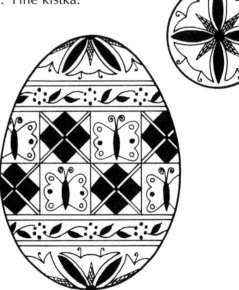

LIGHT BLUE
2. Apply light blue dye with a cotton swab. Use heavy kistka.

LIGHT GREEN
4. Dip the egg into the light green dye for a few seconds only. Repeat the quick dip if the desired shade is not obtained the first time. Use medium kistka.

44

WATER RINSE AND ORANGE WASH

5. Put the green egg into a jar or glass of water to allow some of the green dye to rinse off. Leave the egg in the water about 5 minutes, then dip into orange wash.

ROYAL BLUE
7. Final color.

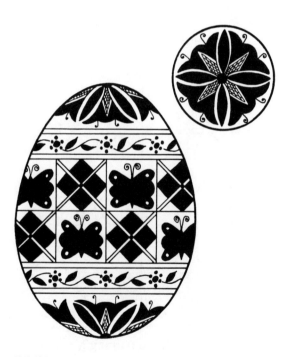

PINK
6. Fine and medium kistky.

BUTTERFLY
Naturalistic symbol denoting the Resurrection.

FLOWER WREATH
Symbolizes the rebirth of nature and life.

EVERGREEN
Health, stamina, and eternal youth.

ROYAL BLUE
Royal color, higher life, and trust.

Egg Number 13

Four Seasons

Pencil:

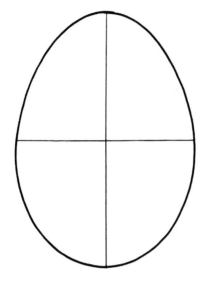

1. Divide the egg into 8ths using the basic division A.

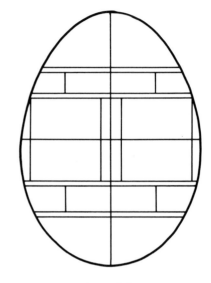

3. Draw vertical guidelines.

2. Add a horizontal parallel lines.

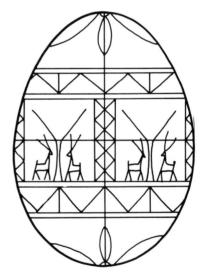

4. Draw deer and remaining guidelines.

Kistka:

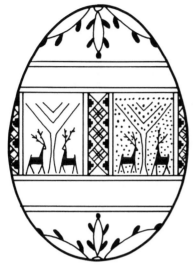

WHITE
1a. Fall/Winter. Use fine kistka.

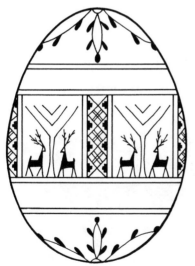

1b. Spring/Summer. Use fine kistka.

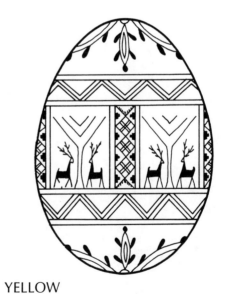

YELLOW
2. Spring/Summer. Use fine kistka.

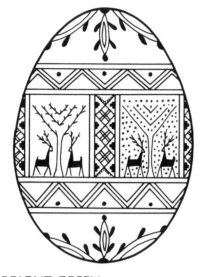

BRIGHT GREEN
3a. Fall/Winter.

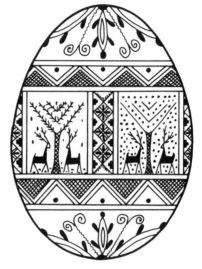

ORANGE
4a. Fall/Winter.

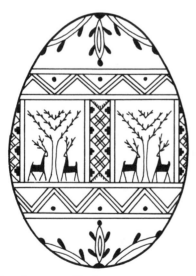

3b. Summer/Spring.
Apply either light green or light blue dye
with a cotton swab to the areas needed.
Use heavy and medium kistky.

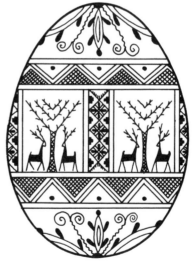

4b. Summer/Spring.
Fine kistka.

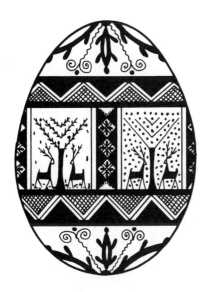

BRIGHT RED
5a. Fall/Winter.

DARK RED
6. Final color.

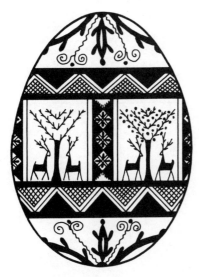

5b. Summer/Spring.
Medium kistka.

STAG
Wealth, prosperity and leadership.

TREE OF LIFE
A unique representation of the tree of life showing it in the four seasons. Symbolizes renewal and creation.

FRUIT
A good life, health and wisdom.

Egg Number 14

Fish

Use light brown egg if available.

Pencil:

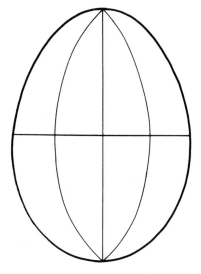

1. Divide the egg into l6ths using basic division C.

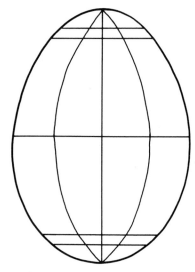

2. Draw horizontal parallel lines at top and bottom of the egg.

3. We are using the eight section flat diagram because it is easier to comprehend the pattern. The eight sections represent half the egg excluding the top and bottom.

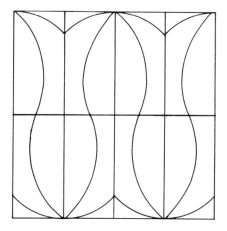

4. Please note that the curves of the fish body are the same in each section.

Kistka:

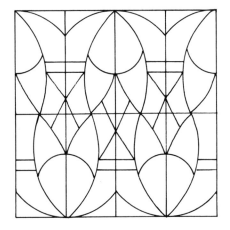

5. Add remaining guidelines.

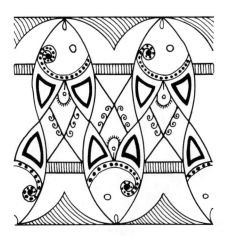

WHITE OR NATURAL BROWN SHELL
1. Fine, medium, and heavy kistky.

51

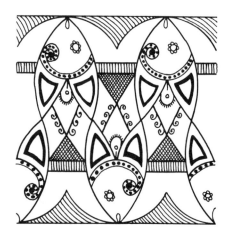

YELLOW
2. Fine kistka.

BLACK
4. Final color.

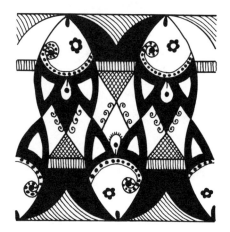

BRICK
3. Medium and heavy kistky.

FISH
Symbol of Christ, dedication to higher ideals.

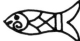

BASKET
Motherhood, the giver of life and gifts.

ENDLESS LINE
Eternity.

BRICK (brown)
Symbolic of mother earth bringing forth her bounty.

Egg Number 15

Horse

Pencil:

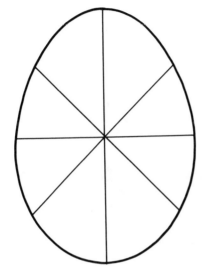

1. Divide egg into 16ths using basic division B.

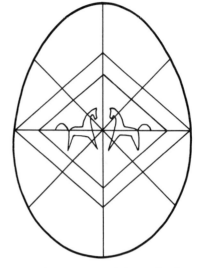

3. Add parallel lines and draw the horses.

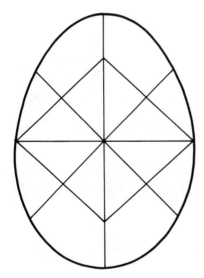

2. Divide each section as shown.

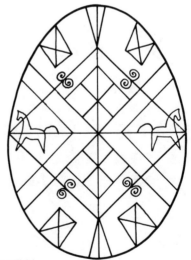

SIDE VIEW
4. Draw additional guidelines.

Kistka:

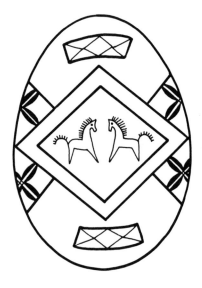

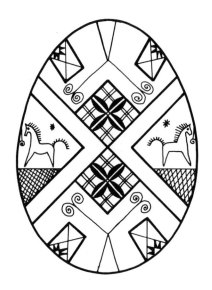

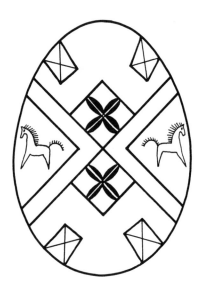

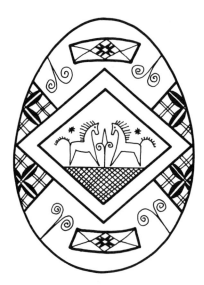

WHITE
1. Start with the heavy kistka to write the main lines. Use fine kistka for the remaining lines.

YELLOW
2. Fine kistka.

54

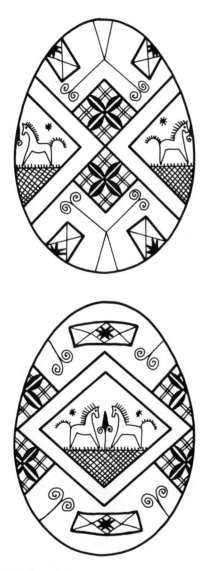

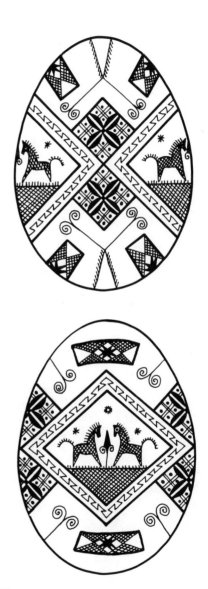

LIGHT GREEN
3. Apply either light green or light blue dye with a cotton swab to the areas needed. Use fine kistka.

ORANGE
4. Fine kistka.

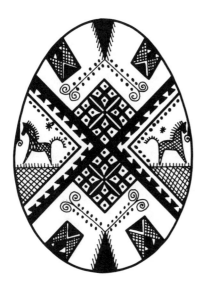

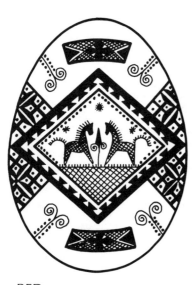

RED
5. Medium kistka.

DARK RED
6. Final color.

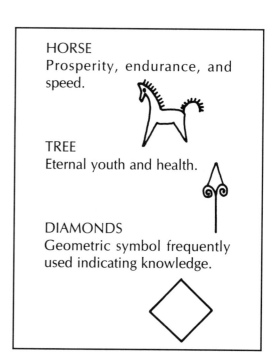

HORSE
Prosperity, endurance, and speed.

TREE
Eternal youth and health.

DIAMONDS
Geometric symbol frequently used indicating knowledge.

Egg Number 16

Bees

Pencil:

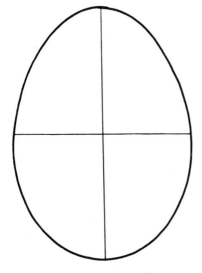

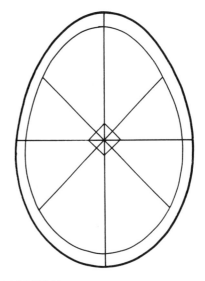

1. Divide the egg into 8ths using basic division A.

FRONT VIEW

3. Divide each section in half stopping at the first border guideline. Draw diamond in center of pattern. This diamond will help you place the bee heads and antennas.

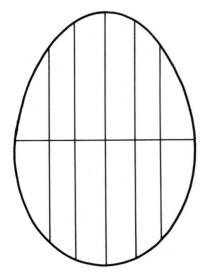

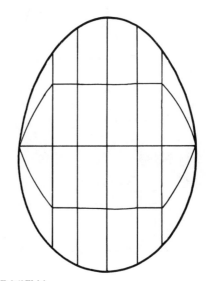

2. Draw parallel lines for the border.

SIDE VIEW

4. Connect division lines.

Kistka:

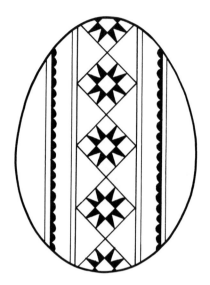

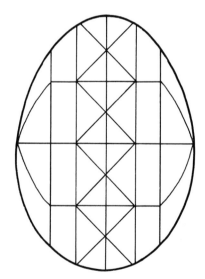

5. Draw in the crisscross lines to form the diamond pattern.

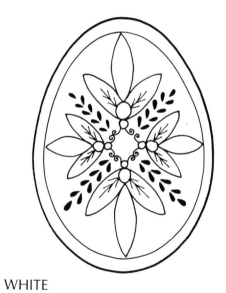

WHITE
1. Use fine and medium kistky.

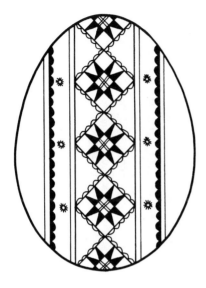

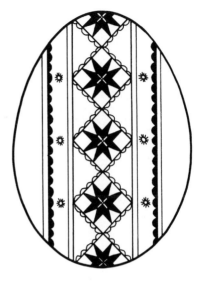

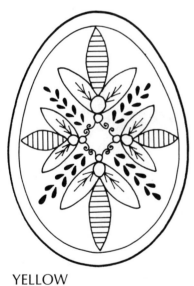

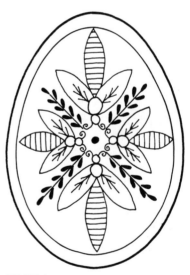

YELLOW
2. Fine kistka.

LIGHT GREEN
3. Apply either light green or light blue dye with a cotton swab to the areas needed. Fine kistka.

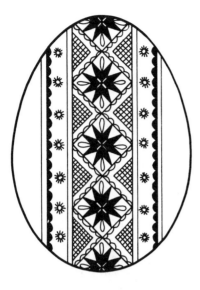

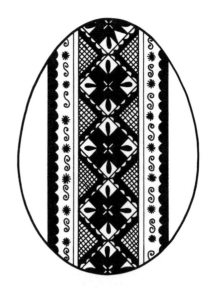

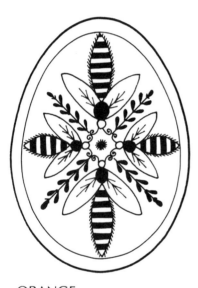

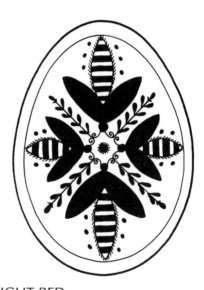

ORANGE
4. Medium kistka.

BRIGHT RED
5. Fine and medium kistky.

PURPLE
6. Final color.

BEES
Important insects (as pollinators of crops and flowers) are the provider of beeswax needed for decorating pysanky. A lovely symbol, but not frequently used.

SPIDER
Patience.

PUSSY WILLOW
Anticipation of spring.

PURPLE
Faith, patience, trust, and fasting.

Egg Number 17

Sunflower

Pencil:

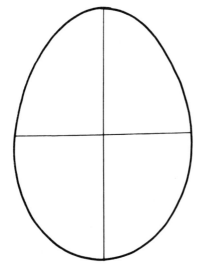

1. Divide the egg into 8ths using basic division A.

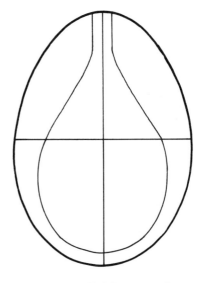

3. Connect the parallel lines as shown.

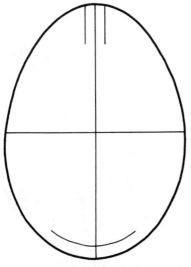

2. On the top (small end), add two short parallel lines to one of the main vertical dividing lines. On the bottom (large end), add two short parallel lines to the opposite vertical dividing line.

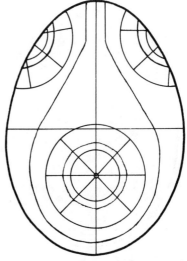

4. Draw circles. Circles can be difficult. Templates, and jar or bottle covers can be used to assist in drawing circles on the egg. Divide circles into eight equal parts.

Kistka:

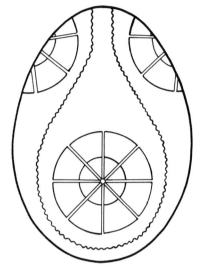

WHITE
1. Fine and medium kistky.

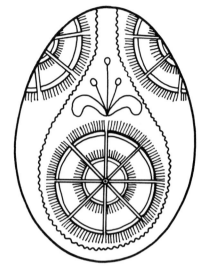

LIGHT GREEN
3. Dip the egg into light green dye. Use fine kistka.

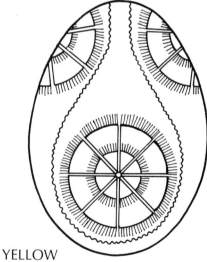

YELLOW
2. Fine kistka.

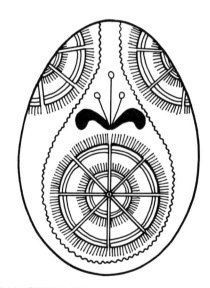

ORANGE WASH
4. To achieve another shade of green, dip the egg into orange wash for a few seconds, until the desired shade appears. Use fine or medium kistka.

62

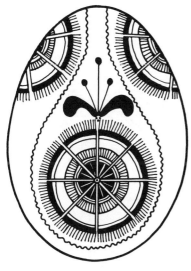

ORANGE
5. Fine kistka.

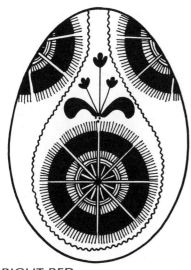

BRIGHT RED
6. Medium kistka.

DARK RED
7. Final color.

FLOWER
Beauty, wisdom, and humility.

SUN
The symbol of life, also signifies
the love of God.

WATER
Abundance and productivity.

Egg Number 18

Cross

Pencil:

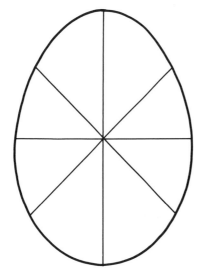

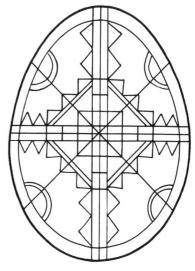

1. Divide the egg into 16ths using basic division B.

3. Start with the cross guidelines and make sure that each square is equal. Add remaining guidelines.

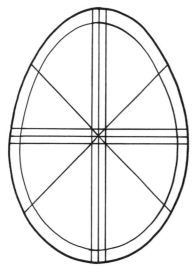

2. Draw horizontal guidelines. Add parallel guidelines to each vertical division line. Be careful not to draw these guidelines too far apart; a little less than 2/10ths of an inch total will be correct for an average egg.

BORDER
4. Draw curved line.

Kistka:

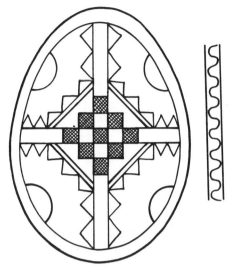

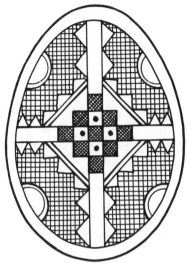

WHITE
1. Use medium kistka for the lines, triangles, and curved line in the border, and fine kistka for the netting in every other square of the crosses.

LIGHT GREEN
3. Apply either light green or light blue dye with a cotton swab to the areas needed. Use medium kistka.

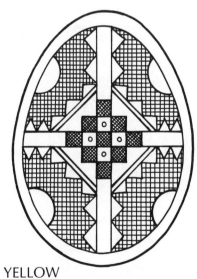

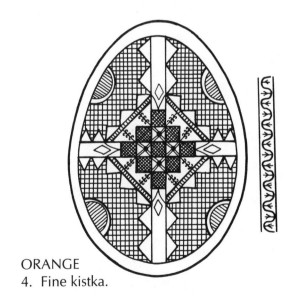

YELLOW
2. Fine kistka.

ORANGE
4. Fine kistka.

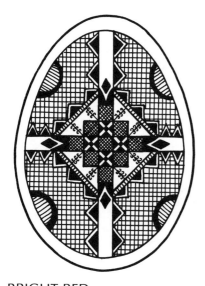

BRIGHT RED
5. Medium kistka.

DARK RED
6. Final color.

CROSS
One of the many varieties of crosses used on pysanky. In pre-Christian times the cross was used as a symbol of life. Ukrainians adopted Christianity in 988 AD and have used the cross exclusively as a symbol of Christian faith since then.

HENS' FEET
Protection of the young.

INDENTED LINE or SAW
A common line variation indicating fire as the symbol of life-giving heat.

Egg Number 19

Red Fish

Pencil:

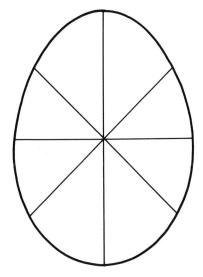

1. Divide the egg into l6ths using basic division B.

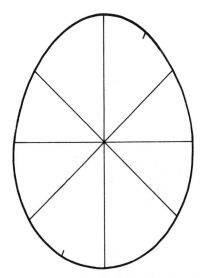

2. Mark opposite sections in half at the vertical quarter line. Turn the egg over and mark exactly the same as the first side.

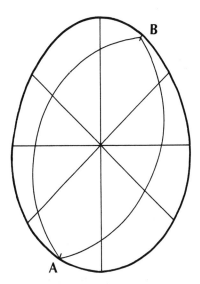

3. Start at the large end of the egg and draw a straight line (with the contour of the egg) from A to B. The line from A to B on the egg will be straight although we cannot show it as such on the drawings. Turn the egg upside down and draw a straight line from B to A. Repeat on the other side.

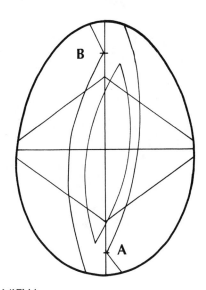

SIDE VIEW
4. Draw leaf.

67

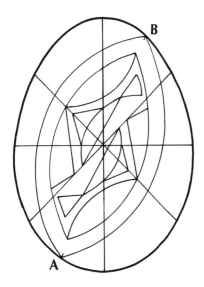

FRONT VIEW

5. Start this step by drawing parallel lines to the lines drawn in Step 3. Draw the geometric fish pattern.

Kistka:

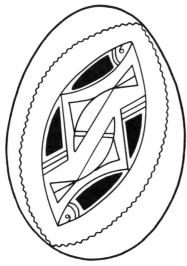

WHITE
1. Use fine kistka on the two inside fish, medium on the rest.

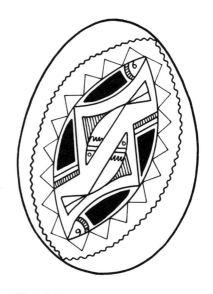

YELLOW
2. Fine kistka.

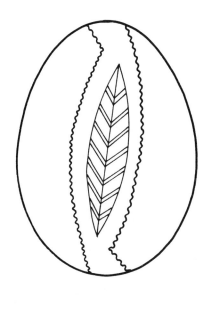

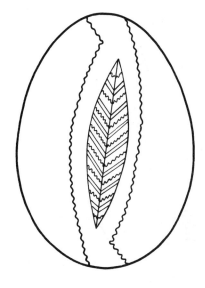

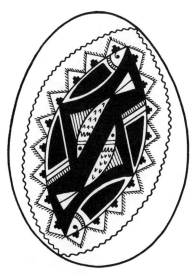

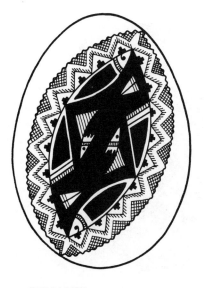

LIGHT GREEN
3. Dip the egg into light green dye. Use
 fine and medium kistky.

ORANGE
4. Fine and medium kistky.

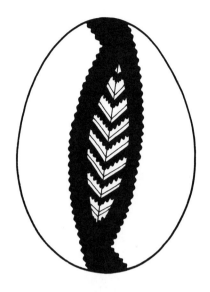

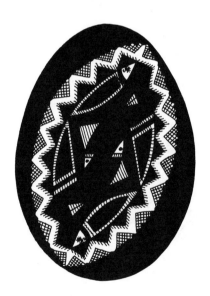

BLACK
6. Final color.

FISH
The symbol of Christianity, is associated with the story of Christ feeding the multitudes with just a few fish.

PLANT MOTIF
Symbolizes the rebirth of nature and the cycle of life.

LIGHT GREEN
Symbolizes the breaking of shackles and freedom from bondage.

BRIGHT RED
5. Fine, medium, and heavy kistky.

Egg Number 20

Triangle

Pencil:

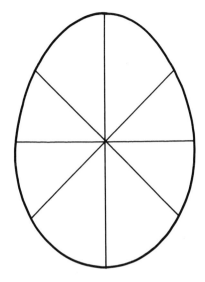

1. Divide egg into 16ths using basic division B.

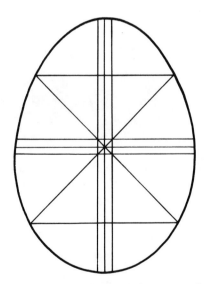

2. Draw horizontal guidelines. Add parallel guidelines to each vertical division line. Be careful not to draw these guidelines too far apart, 2/10ths of an inch total will be correct for an average egg.

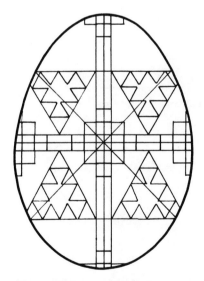

3. There are four cross designs around the egg and one on each end. Start with the cross guidelines and make sure that each square is equal. Add the large triangle guidelines and then the small triangles within.

Kistka:

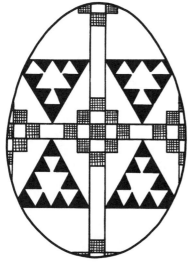

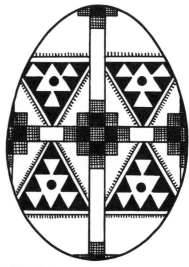

WHITE

1. Use medium kistka for the lines and triangles. Use fine kistka for the netting in every other square of the crosses.

LIGHT GREEN

3. Apply either light green or light blue dye with a cotton swab to the areas needed. Use medium kistka.

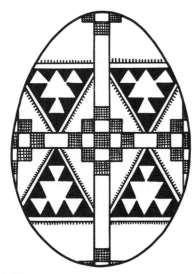

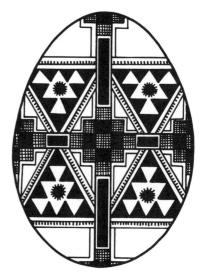

YELLOW

2. Medium kistka.

ORANGE

4. Fine and medium kistky.

TRIANGLE with CENTER CIR-CLE — God's eye.

TRIANGLE
Holy Trinity or earth, air, water or the three stages of man.

ORANGE
Symbolic of the everlasting sun.

Egg Number 21

Hutsul Woman

Pencil:

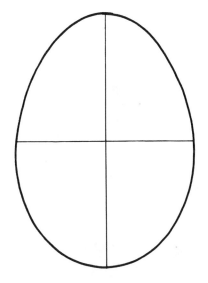

1. Divide egg into 8ths using Basic Division A.

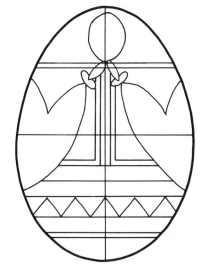

3. Draw in additional lines as shown.

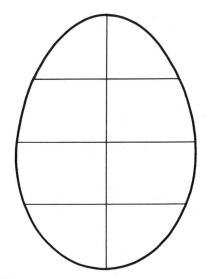

2. Draw horizontal lines.

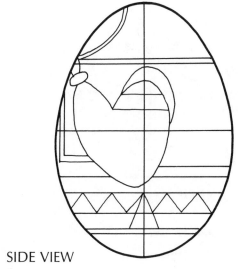

SIDE VIEW
4.

Kistka:

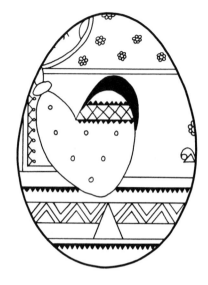 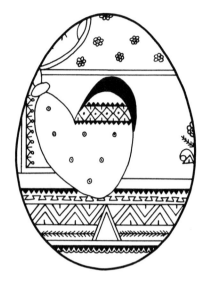

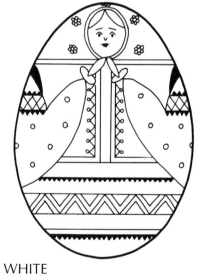 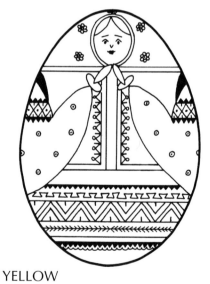

WHITE
1. Fine kistka.

YELLOW
2. Fine kistka.

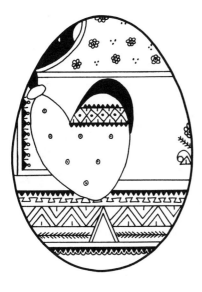

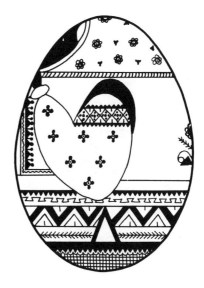

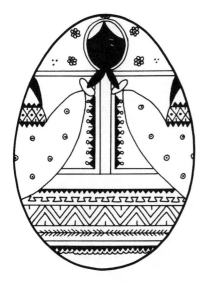

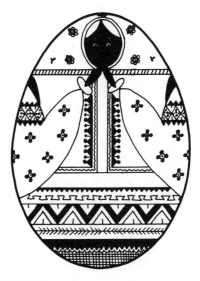

LIGHT GREEN AND LIGHT ORANGE

3. Use a cotton swab to apply green to front of vest and scarf. To achieve a light orange (skin tone), dip a cotton swab into water then into the orange dye. Test to make sure that it is not too bright by dabbing a little on a sheet of white paper. Apply to the face and hands of the Hutsul woman, pat dry immediately. Use medium kistka.

ORANGE

4. Fine and medium kistky.

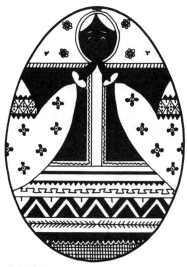

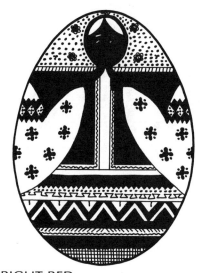

BRICK
5. Heavy kistka.

BRIGHT RED
6. Medium kistka.

BLACK
7. Final color.

The Hutsul woman is from the mountain region of Ukraine. The scarf covering her head tells us she is a married woman. Her hands are in a praying position. This is a nontraditional original egg decorated by Luba Perchyshyn.

Egg Number 22

Goose Egg

We show this pattern on a goose egg. It can also be used on chicken eggs.

Pencil:

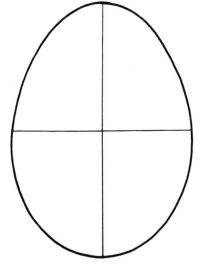

1. Divide the egg into 8ths using basic division A.

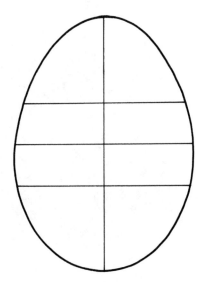

2. Draw horizontal parallel lines.

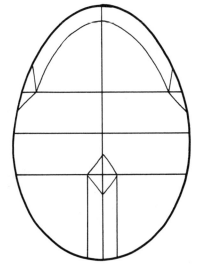

3. Draw vertical parallel lines and then complete the diamonds.

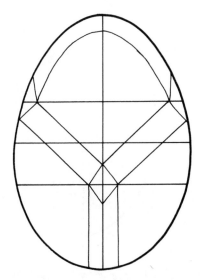

4. Connect diamonds with the diagonal parallel lines.

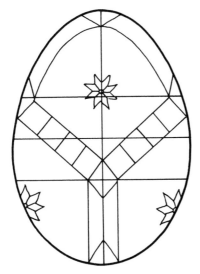

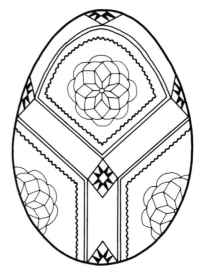

5. Center stars in each section. Draw in the remaining diamonds. Divide diagonal sections into four equal parts.

1b. Write parallel lines and star with fine kistka. Use heavy kistka for bold lines.

Kistka:

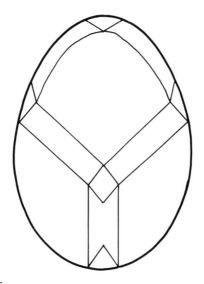

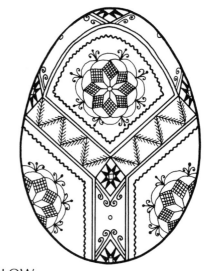

WHITE
1a. Using fine kistka write diamonds first, then connect.

YELLOW
2. Fine Kistka.

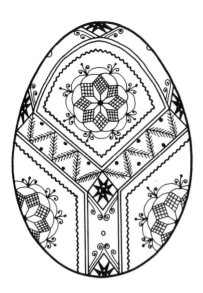

LIGHT GREEN
3. Medium kistka.

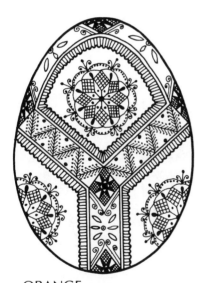

ORANGE
4. Fine kistka.

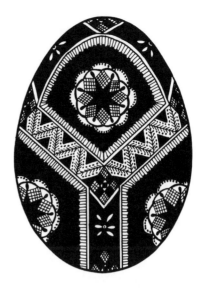

BRIGHT RED
5. Use heavy kistka to fill in large areas and medium kistka for the remaining red.

BLACK
6. Final color.

ROSE
Love and caring.

PINE NEEDLES
Eternal youth and health.

LADDER
Symbolic of searching, good husbandry.

RED
Sun, happiness in life, hope and passion.

Egg Number 23

Stars

Pencil:

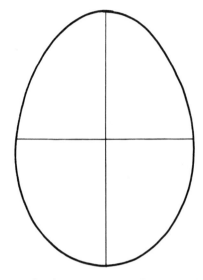

1. Divide the egg into 8ths using basic division A.

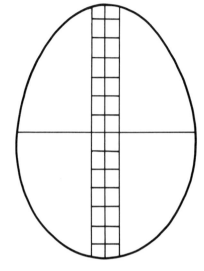

3. Divide each section into 7 equal parts.

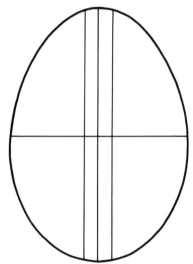

2. Add parallel lines. These are your border guidelines.

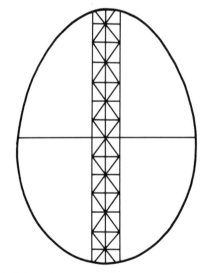

4. Add crisscross lines to form the diamonds (14 total).

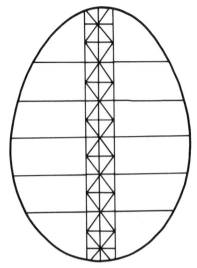

5. Use the ends of the diamonds for spacing of the horizontal guidelines.

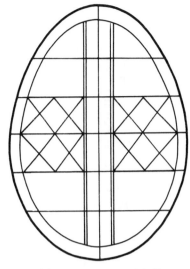

7. Add remaining guidelines.

Kistka:

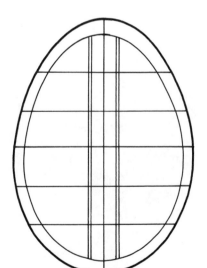

6. Add vertical parallel lines for the diamond strip on the front of the design.

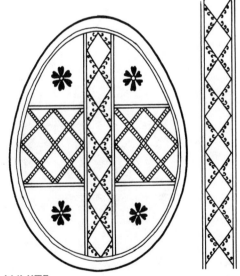

WHITE
1. Write parallel border lines first. Use fine kistka.

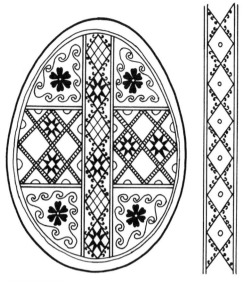

YELLOW
2. Fine kistka.

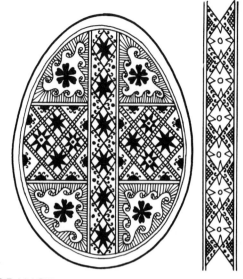

ORANGE
4. Fine kistka.

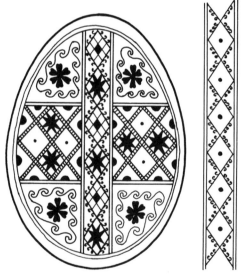

LIGHT GREEN
3. Apply either light green or light blue dye with a cotton swab to the areas needed. Use medium kistka.

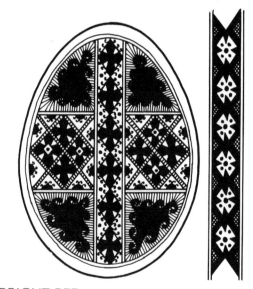

BRIGHT RED
5. Medium kistka.

DARK RED
6. Final color.

FLOWER
Beauty, wisdom, elegance.

LADDER
Prayer, ascension to heaven.

STAR
A frequently used symbol, denotes life itself, the giver of light, or God's love toward man.

YELLOW
The color of light, denotes youth, happiness, love, and kindness. It is the Christian symbol of recognition and reward.

Egg Number 24

Hutsul Geometric

Pencil:

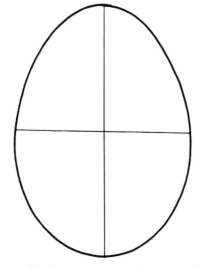

1. Divide the egg into 8ths using basic division A.

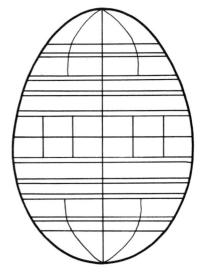

3. Divide each quarter in half vertically at both ends. Divide the middle section into 12 equal parts (3 sections per quarter).

2. Draw horizontal guidelines.

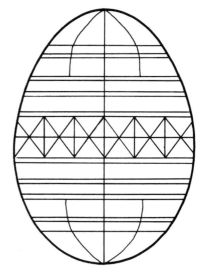

4. Draw crisscross lines to form the diamond pattern.

5. Draw another set of crisscross lines to form double diamond pattern. Draw additional guidelines.

YELLOW
2. Fine kistka.

Kistka:

WHITE
1. Fine kistka.

LIGHT GREEN
3. Use a cotton swab to apply light green or light blue dye. Use fine or medium kistka.

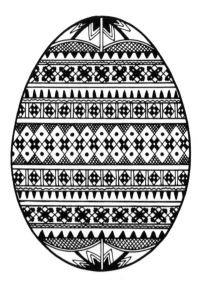

ORANGE
4. Fine kistka.

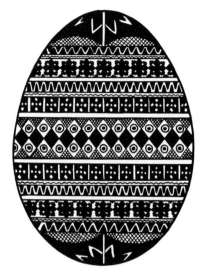

DARK RED
6. Fine or medium kistka.

BLACK
7. Final color.

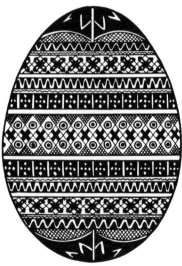

BRIGHT RED
5. Fine and medium kistky.

ST. ANDREW'S CROSS
St. Andrew was crucified on an X shaped cross. This symbol honors his work for Christ. Ukrainian legend tells that St. Andrew preached in Ukraine. He foretold that one day a beautiful city with many chur-ches would be built along the shores of the Dnipro River. That city is Kiev.

DIAMOND
Indicates knowledge.

WOLVES' TEETH
Loyalty, wisdom, and a firm grip.

Chapter Six
Finishing the Eggs

Removing wax from the shell

Removing the beeswax from the shell is probably the most exciting step in decorating pysanky. This is the magical step where we finally get to see the color and designs that we have been creating. We use any one of the following methods for removing the wax:

I. Candle Method

We often melt the wax using a candle flame. This is done by holding the egg in the side of the flame until the area looks wet, about 2 to 5 seconds. Immediately, with a clean soft cloth or tissue, wipe off the melted wax. Be careful not to hold the egg over the top of the flame because the carbon will collect on the shell and darken the design. Do not attempt to heat too large a portion of the egg at one time. After you have finished removing all the wax, blow out the candle and gently wipe the egg with a tissue dipped in a small amount of cleaning fluid. The cleaning fluid will remove any carbon and wax that may still be on the shell. It is important to have a clean shell before varnishing.

II. Oven Method

Preheat the oven for 10 minutes at 200 degrees with the door open. Put the eggs on the egg rack placed in the center of the oven until the wax begins to melt and looks shiny. This should take between 8 and 15 minutes. Remove the eggs one at a time and wipe with a soft cloth or paper towel. It is not necessary for the eggs to get very hot, just warm enough to melt the wax. This method is cleaner than the candle method. Be careful not to leave the eggs in the oven too long if it is your intention to empty the egg from the shell. Eggs that are even partially baked are difficult to empty. You may prefer either the candle or cleaning fluid methods for the eggs you will be emptying.

III. Cleaning Fluid Method

Removing wax from the egg with cleaning fluid is not done very often. However, once in while it can be used. You may want to use it if you are planning on emptying an egg. Also, it is the preferred way to clean bleached eggs. Soak a tissue or paper towel with cleaning fluid and gently rub the egg with the wet tissue. The cleaning fluid will melt the wax. Keep rubbing gently until you remove all the wax. Toward the end of removing the wax you will need to start over with another tissue soaked with cleaning fluid. This method is messy and lengthy.

Blown eggs

Blown eggs take only a short time to heat. Be careful not to scorch them either with the candle or the oven method. If you are using the oven method, do only a few eggs at a time. They will be warm enough in 1 or 2 minutes. It is important to observe the eggs throughout the procedure. You may choose to use cleaning fluid to remove wax from a blown egg.

Varnishing

The materials needed to varnish the eggs: newspaper, clear gloss varnish, drying rack, waterless hand cleaner(soap), and paper towels. Spread the newspaper and open a small can of varnish. Put the tip of your index finger from one hand directly into the varnish. Allow a few drops of varnish to drip from your finger onto the palm of your other hand. Place the pysanka into the palm with the varnish. Roll the pysanka around the palm of your hand with the fingers from your other hand. Be sure you have covered the entire shell with a thin coat of varnish and place it on the rack to dry. Repeat process for additional eggs. One or two drops of varnish will be enough for each additional egg. Allow to dry completely (12 to 24 hours). If the eggs are sticky at all, do not apply additional varnish or they will never dry. After the egg is thoroughly dry, apply a second coat for a high-gloss finish. A third coat may also be added.

To clean the varnish from your hands, first wipe off the excess on a paper towel. Then, rub your hands with hand cleaner, cold cream, or fat - such as butter, lard, bacon grease, or shortening. Wipe hands off with a paper towel and wash with soap and water.

Emptying eggs

Eggs may be blown either before or after decorating. If you blow them first, the insides of the eggs can be saved for cooking. To empty the contents, pierce a hole at each end of a room temperature egg using a hat pin or a fine drill. Keep the holes as small as possible. Insert a long pin and pierce and break the yolk inside. Shake the egg vigorously to mix the inner contents. Hold the egg over a bowl and blow through the top hole to force the contents out.

A second method requires purchasing a special egg blowing bulb. Squeezing the bulb forces air into the shell and the contents come out quickly.

After the egg has been emptied, rinse out the inside of the shell with a mild water and vinegar solution, (1 cup water and 2 tablespoons vinegar), blow again and allow to dry. Set the egg on the drying rack to dry.

The holes in the blown egg must be sealed before dying. We put a small drop of hot beeswax over the hole with the kistka to seal it. Because the shell is empty, it will float in the dye. Therefore, weigh it down with a small jar filled with enough water to hold the egg under the dye.

If you decided to blow the egg after it has been decorated, it must be done after the egg has been varnished. The dyes are water soluble and will run from either the egg or the rinse water, so the shell needs varnish for protection. The insides of these eggs cannot be used for cooking because the dyes may pentrate the shell and they are not edible.

If you do plan to blow out your eggs, do not allow them to get too hot in the oven when melting the wax. Cooked eggs are impossible to blow. You may decide to melt your eggs with the candle instead so the insides remain raw. It is best to blow out all the eggs while they are still fresh.

Hanging Eggs

If you wish to suspend a pysanka as the Ukrainian peasants did in their homes and barns, we suggest either of two methods.

Tie a long length of narrow ribbon, cord or thread to the middle of a toothpick. A small amount of glue may be smeared on the stick where the thread is tied to keep it from slipping. Carefully, insert the toothpick straight down into the hole (Figure 1). The stick will become wedged crosswise inside the shell and will not pull out (Figure 2).

Another method, especially good for hanging blown eggs on the Christmas tree, is to glue a finding to the top of the egg, allow to dry overnight, then thread a cord or fine ribbon through the loop in the finding and you have a beautiful handmade ornament ready to enjoy (Figure 3).

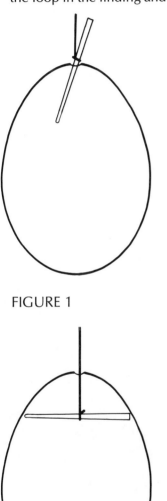

FIGURE 1

FIGURE 2

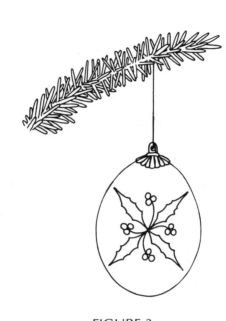

FIGURE 3

Egg tips

You will have the best results with your pysanky if you:

1. Use only fresh eggs with good firm shells.
2. Check your work before dying the egg to be sure all your lines are completed.
3. Keep the finished pysanka out of the sun.
4. Do not store whole pysanky in a tight place where the air is not circulating freely. A plastic carton or a china cabinet which has tightly closed doors inhibits normal air circulation. Paper cartons are suitable to use for storage.
5. Handle as little as possible.
6. Protect full eggs from extreme heat or cold. Do not use spotlights or store eggs in the attic where they might freeze or get excessively hot.
7. Do not take cold eggs from the refrigerator and submerge them in hot water to warm them for decorating. Allow them to come to room temperature normally.
8. You may prefer to empty your eggs if you have spoilage problems.

INFORMATION ON PURCHASING MATERIALS

The materials needed for decorating eggs in Ukrainian style can be supplied by:

The Ukrainian Gift Shop, Inc.
2422 Central Avenue Northeast
Minneapolis, MN 55418 3787
Area Code (612) 788-2545

Or, contact your local Ukrainian or craft store.